T0283295

Unshuttered

Unshuttered

POEMS

PATRICIA SMITH

TriQuarterly Books / Northwestern University Press
Evanston, Illinois

TriQuarterly Books
Northwestern University Press
www.nupress.northwestern.edu

The vintage photographs that appear in this book are found objects, and little
information is available about the photographers or the persons depicted. The
poems are the product of the author's imagination and do not literally represent
actual people, places, or events. The integrity and mystery of the subjects remain,
and no disrespect is meant to these individuals, whose names are largely unknown,
or to their family members.

Printed in Canada

10 9 8 7 6 5 4 3 2

Library of Congress Cataloging-in-Publication Data

Names: Smith, Patricia, 1955– author.
Title: Unshuttered : poems / Patricia Smith.
Description: Evanston, Illinois : TriQuarterly Books/Northwestern University
 Press, 2023.
Identifiers: LCCN 2022051834 | ISBN 9780810145634 (hardback) |
 ISBN 9780810145641 (ebook)
Subjects: LCSH: African Americans—Social conditions—19th century—Poetry. |
 LCGFT: Poetry.
Classification: LCC PS3569.M537839 U67 2023 | DDC 811.54—dc23/
 eng/20221101
LC record available at https://lccn.loc.gov/2022051834

To my father. Who was before me. Who was before everything.

And to the lost-ago voices that guide me still—

Gabrielle Bouliane
Gwendolyn Brooks
Lucille Clifton
Wanda Coleman
Claudia Emerson
Monica Hand
Ilyse Kusnetz
Kamilah Aisha Moon
Venus Thrash

You are not and yet you are: your thoughts,
your deeds, above all your dreams still live.

—W. E. B. Du Bois

There is no agony like bearing an untold
story inside you.

—Zora Neale Hurston

For years I clawed through moldy boxes at garage sales, scoured online markets, and battled spiders in attics searching for nineteenth-century photographs of African Americans. I have amassed a collection of more than two hundred cabinet cards, cartes de visite, ambrotypes, daguerreotypes, and tintypes. They were not easy to find. Even after the Civil War, few Blacks had the resources or freedom to sit for a portrait.

These images—each captured between 120 and 180 years ago—represent a time when former slaves learned to redefine the word "home," and even those born after Emancipation struggled to redefine the word "free." Only a few of the images have a name scrawled in pencil on the back. Often, it is only a first name. Sometimes the full name is given or the location of the studio is identified, but rarely is there anything more.

Confined within the stifling boundaries of the photographs, these men, women, and children peer at us from the past. They cannot laugh, weep, speak, or scream.

They are wraiths, their stories growing dim.

From the moment that I happened upon my first nineteenth-century photograph of a Black person, at a Connecticut flea market twenty years ago—a dim, water-streaked image of a slyly smiling woman swallowed by an elaborate hat (p. 16)—I have been distressed by this silence.

As my collection swelled, I spent hours staring at the pictures, and the silence became a roar. The ghosts arced toward breath and story, ached to be remembered and heard.

I recognize this need because I, too, have lost my history. My mother, who traveled from her home in Aliceville, Alabama, to Chicago during the Great Migration, was so ashamed of her impoverished Southern roots that she severed them, urging me to think of her life as beginning in 1950s Chicago. The only hint of her past was a battered suitcase full of faded Polaroids of people she refused to identify. Looking behind me, I see nothing that says: *That is where I come from. This is who I am.* But I'm not the only one surrounded by silence. Many African Americans of my generation tell similar stories.

So I became obsessed with conjuring voices that reflect who the subjects in the pictures may have been and how they are inextricably connected to us.

Of all the people in these photographs, only Moses Grimes (p. 50)—whose father, Harry, escaped from slavery and then assisted others on the Underground Railroad—is positively identified. When the location of the photo studio is known, the corresponding poem often reflects a historical event such as a lynching in Wytheville, Virginia, and a yellow-fever outbreak in Memphis. But most of these stories come entirely from what I imagined as I looked into the faces of my forebears.

ACKNOWLEDGMENTS

I am eternally grateful to the John Simon Guggenheim Memorial Foundation, the Civitella Ranieri Foundation, and Claremont Graduate University, presenter of the Kingsley Tufts Poetry Award, for the time, financial support, and treasured solitude I needed to complete this project. I also owe so much to the inimitable and invaluable community of Cave Canem, where the seed for *Unshuttered* was first planted when my students saw those faces and cleared a pathway back in time. The poems of Cave Canem fellows Roger Reeves and Antoinette Brim, more than any others, inspired me throughout the conjuring of *Unshuttered*. I pray I've done those poems justice.

I extend appreciative acknowledgment to the editors of *Prairie Schooner*, where the poems numbered 8, 9, 25, 35, and 37 first appeared, in largely the same form.

All my students—at Cave Canem, the City University of New York, Princeton University, Sierra Nevada University, St. John's University, the Vermont College of Fine Arts, VONA, and in many other residencies and workshops—questioned my creative choices, taught me their strengths, and disproved the notion that there could ever be an end to learning.

I only hope I've learned enough to deserve them.

My good friend and trusted mentor, Kwame Dawes, is my forever first reader. He knows my voice intimately, realizes immediately when I'm not reaching far enough, and calls me on it. He's tough, and his unerring guidance has never failed to raise the work. Also, much love to memoirist / poet / actor / artist / photographer / soldier / builder Benjamin Busch and to my bestie, Los Angeles poet laureate Lynne Thompson, who pushed me forward after reading this book in an earlier incarnation. (Lynne, thanks for being the questionable influence I need at this time in my life—and yes, Ben, *you said it.*)

Here's to Ellen Bass, Toi Derricotte, Cornelius Eady, Nikky Finney, Terrance Hayes, Tim Seibles, Michael Warr, Afaa Weaver, The Coven, the Dark Noise Collective and the DeSilva family, and everyone who's ever

tripped through the sublimely shambolic world of the poetry slam—I'm forever grateful for your impact and your outstretched arms.

I'd like to thank my mother for shrouding her history and my father for celebrating his.

Bruce—you're relentless. I've never had anyone believe in me the way you do, which I know is a consequence of love. Mikaila and Damon, it's you and me against the world. It has been from the beginning. And the world's still not crazy about its odds.

Unshuttered

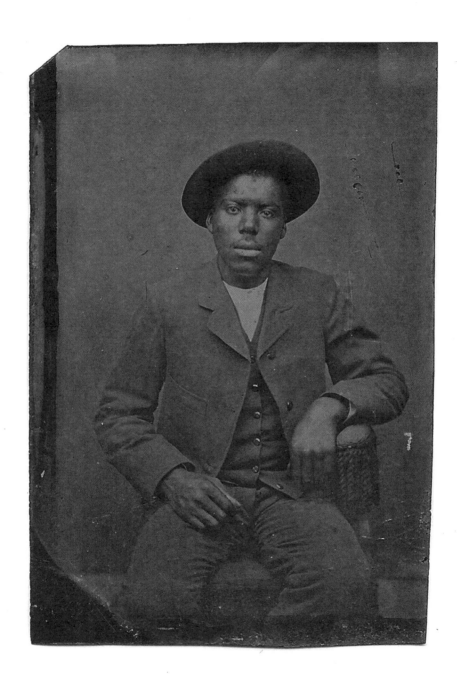

1

You crush me with your damning glimpses, Anna. You,
so rancorous, so wounding, and so cruelly bred
to stain a man with scarring he won't see. Unsaid,
my reckless want of you—this yearning, thirsting, blue
inside these hands—is seed for malady, the mud
that clogs my throat, a pantomime of moan and knees.
Go home, you growl. I slip by agonized degrees
into the sound. You mouth my name, unlatching flood.

I beg you, Anna, search for mercy—heave my hurt
and humbled body close, let pity drive your slight
unwilling hips into the waiting, sweated blight
of mine. Let loose that rasping whisper—*Shed your shirt*—
and raze me slow, your mouth demolishing the rest
of who I am, until I gasp defeat against
the firelight in your neck. I just can't see the sense
in your bedevilment. What keeps you so possessed

by whiter gazes, dreaming you're the fool of those
who'd ravish without wonder? Come home to the skin
you know. Come staunch this mayhem with the medicine
inside your sacred hold, give me what you suppose
that white man craves. Oh Anna, drop me to my knees
and call the shaming love. By now, I must have riled
you past vexation into wanting. If not, I'll
crouch here in blue, content to be your wreckage.

Please.

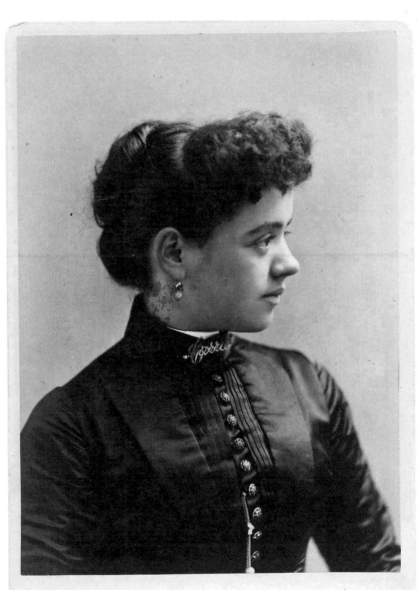

2

Officially composed and gracefully caged
inside your picture-perfect City on a Hill,
I am queen of my thin path, daring thresholds,

justifying this languid sway of lace. You sniff
as if I am a blunder in the air, your ashen stare
fixed on my woolly curls, my audacious stroll,

the glint of naming at my neck. So much
fresh North in you—you strain to trap the spit
behind your teeth, hating that you know

I will not run, neither toward you nor away.
I am not my mother, squatting howler whose
body spat a squalling into dust, who hurriedly

crammed all her heat inside the niches of my name.
Stubborn verb upon the river muck, she hexed
and menaced the dark 'til it gave up on dawn.

I am not that woman. But I *am* that woman's
daughter, stomping Boston's stony paths,
flaunting silks that I deserve. My step

is fierce, pulsing with my mother's frantic
maps. As she wished, they have led me here,
to door after door, and each door must open,
and only I choose whether to step inside.

3

My mother—gray and girdled, stifled in an overdue
array of futile finery—would squirm, annoyed, if she
could feel that itchy tug and scrape of ribbon at her throat.

That throat? It's dead. Her knees, those hands, the nappily askew
eruption of her hair (which someone briskly tamed so we
would not be shamed). All dead: that flimsy, fussy woolen coat

that Maine wind whipped to thread. Her holy solos in the hue
of mint and bourbon. Both her arms, gone swole by forty-three
years of a husband's work. Her mouth that hissed out what she wrote

in livid letters to that long-gone man. Muscled legs laced
indigo with meandering roads. Brogans that can't know
they'll never roam again. The heart that hammered in my ear

when we, two wary newborns, met. All of her gone to grace,
to ghost, to glory. *James, she's with our Lord,* folks whisper—so
the Lord and I refuse to speak most days. It sure appears

He's pilfered all there was of Ma, forcing me to embrace
this stranger, petrified and prettified, as kin. Although
I conjure well the moves of mourning, bending to be near

this unblessed face now silenced under layers of blanching pink,
it's all so wrong. If you knew her, you'd know that calico,
not all this rampant silk, would bed my mother best toward rest.

I cannot be this woman's son.
I did not rise from glow.

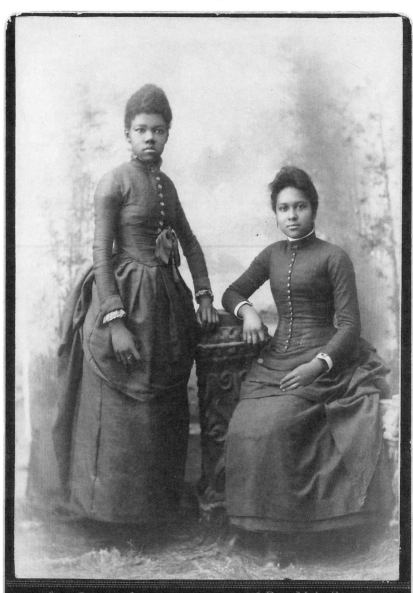

4

I

She's buttoned and laced up so stiff

staged so black and (whew, Lord she) *mad* the photographer asks (asks!)
me to sit *please ma'am* gleams at my bound

chest and my sister I swear she sucks all that mad through her teeth
like a sow

ugly
 and *mad*

he stands her over me like a man would stand
pushes her limbs where he
wants them laughs when light won't
crawl through her hair

 look at that chile
looking just like
 whosoever her damn black daddy
was
guess ain't no harm
 in loving her plain ass
 even tho

II

I always know the very second she decides to believe
she can love me. She shudder-sighs, and her tight little
lips twitch, like Mary when she first saw that cross

and knew what it meant. Oh, how my sister has sacrificed
to weep woe under the millstone of me, poking at my face
for a disappeared link to our mother, for any reason

at all to declare me mistake instead of sister. She hates
knowing that I'm alive because our mother dropped and found
what she desired in the dirt, when a long-ago weather rose up

and took hold of her thighs and hands. My sister's white
daddy was a thief who ran away with what he left behind.
She and I stare at the camera. Every gone father glares back.

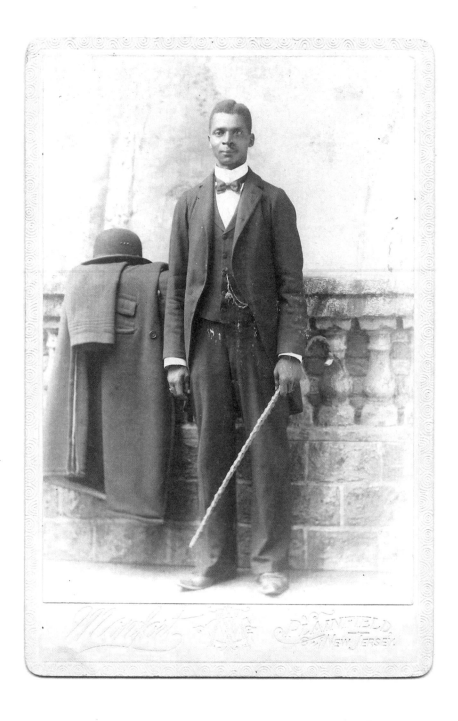

5

A waylaid rage illuminates when I consider sight.
Wild-waving my cane, I stagger forth in muttered *damn-it-alls,*

get mad inside my fretful legs, then tumble again into blunder,
failing familiar paths. The Lord mutters too, claiming He adores

me. He watches as I amble like a fool in all directions at once,
coos *Do not resist the one who is evil* while I drown in the sour

spew and spittle of His children. He whispers *We live by faith,
not by sight* while I lurch over His sawtooth stones, undone by

the day's sudden plummet, the tricky width of walls, laughter
at my back. Each day, shady and sable, begins as it ends, with

another me twisted in its cloak. When I wake from sleep, He
bears witness to my wild thrashing, droning psalms while I beg

to know if it's the sun or the moon sputtering its desperate blush
above my head. I stun my tongue, holding back the lazy praise

I've been trained to babble, because some simple miracle—*God
woke me up this morning*—won't ever be enough. Let Him bless

my wobble and foolish turns, flung stones stinging my best topcoat,
the hot gush of horseshit under my shoes. I'll never see any of it.

Once, with just my hands, I found the father in a man's face.
He told me, sugar-slow, how sun rises, how moss droops

the cypress. Boy, he said, you look just like me. He hugged
me so hard I could see him. So hard my rage smoldered shut.

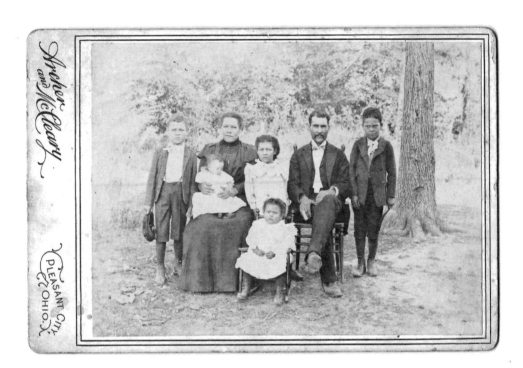

6

Bea, come. It's such soft fist, first light, hefted
like a lantern
to our faces. Gather
the children
 —all pout and grumble, I'm sure—tell
them that we won't be

this exact moment

ever again that the morning
will soon forget to say our names this way—

Luke and Dalia, Marie, and baby Beth (squirming,
 straining for the sweet familiar of her dirt),

 and Robert, so much darker (Bea?)
 than me

 the slow-stitched wound
 of his eyes

Soon he will say some sharp thing to confound
 the light
 but now

let us treasure this stillness
and the way it dazes

the all of us

 in gold
 in place

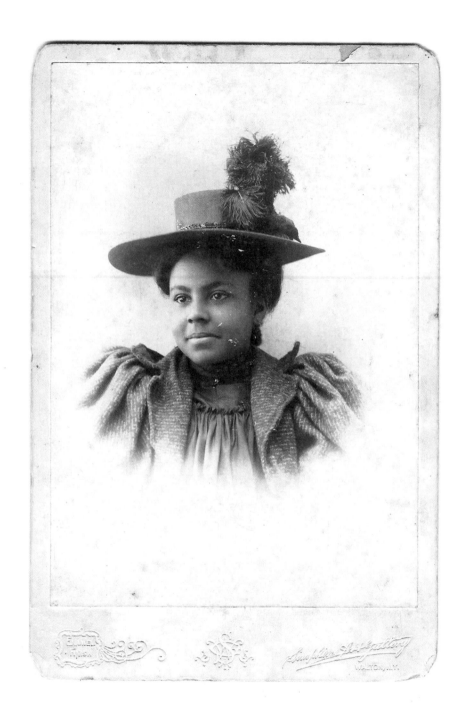

I hold my breath to tempt the light. This portrait should engage
the interest of some decorous and cultivated gent
accustomed to the ways of wooing. All my life I've sent
so many men so many signals, just to be upstaged

by silly girls who rose up from their cribs perfumed and pressed
and batting their outrageous eyes. Still, I believe I'm spry
enough to take them on and win—soon I'll be swept up by
a strong and simple man who's weary of the jealous mess

those gals can be. You'll never catch me gasping in a frock
that lies about what's underneath, or shoes that shriek my feet.
I'll be just me—a wee bit corseted, some swipes of sweet
cologne, my mother's wobbling plume. I now have taken stock

of all this me I offer—there's no choice but to give in.
Wherever and whoever and whatever he may be,
my skin just puckers at the thought of him bewitched by me,
by me! It's damned near time for this beginning to begin.

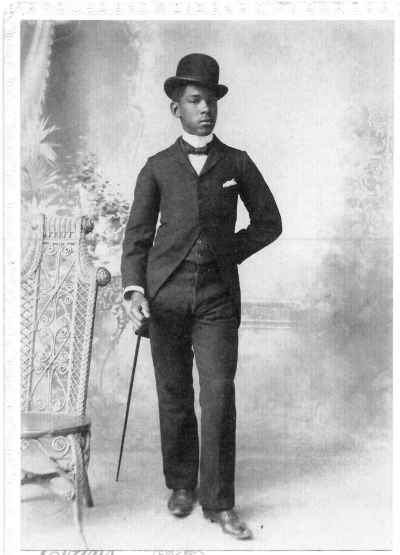

Evans Finish MIDDLETOWN, N. Y.

cane, cravats, and corsets tell and retell the body's story the shell we
shroud in guile, romance, and thread i was a doll i was a sleek fool i
was publicly foppish loud as a lit lamp but my shoes, their upturned toes

dust and scuff *a negro's always got nigger somewhere on 'im all you gots to
do is*

Look

They couldn't let me occur not like this not
this me not my Sunday self not not like upright not like stroll like
matchstick Like *la-di-fuckin'-da boy gotta find a crime for you*
their rhythm partial to the red air down around my knees
she/point//shriek//point//shriek/she/ the point is i was where i was
 when i was there
it's true my eyes may have swept a woman an hour idea or a

future

 i didn't own she/point/she who knew that
there that boy is that the boy yessir that the boy could be a whole trial
sometimes even christians get necks wrong i was not *that boy*

i used to twirl a walking stick and dip my crown toward a sun that
relished
my body

but
when we forget that fancy only rolls
 one way

 some body
 reminds

 us

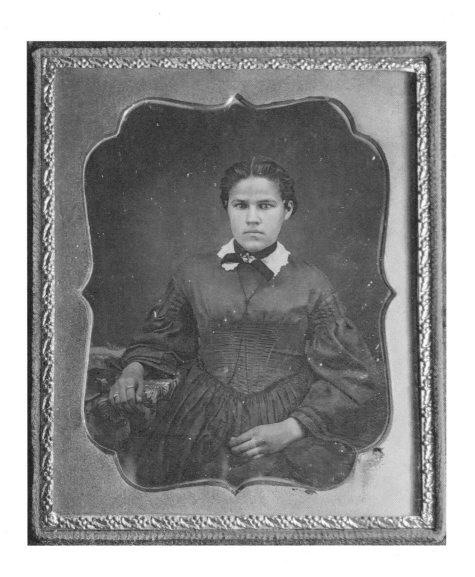

9

The woman's body spat forth mishap—me, such tiny hell.
She squalled a bend in the twilight, and a recollected woe cut clear

through me, stretching open what needed to heal. My mother
was bothered kin to a reeling ocean's root. Somewhere near

the surge's edge, she had a talk with drowning, and they danced close,
before the man, reeking of a backwash of blood, swung his glare, a leer

toward her, then forced her wide to make damn sure she measured right
for hasty trade. After he lashed his life to hers, no prayer steered

him clear of celebrating his sudden bellowed freehold of body.
She sensed the churn in her legs then, a coveting of an elsewhere clear

across sweep of cur and prickle. But it was years before she all the way
went gone, pummeling steps ahead of yelp and torch, a bare fear

numbing the work of her chest. She misread a river and man and men
were on her, whooping bile, too drunk on prey to declare their sheer

awe at the blazing in her gaze. The strap pretended to quiet her. No one
realized me, a notion already seething. *They're nothing. They're mere*

men, she hissed, and they heard. I heard. Even now, she raises much ruckus
for a woman so dead—thrashing through moonwash, bellowing blare near

my dreaming ear. She will never not be torch in me. I am Mercy, born
of the runner. Now, if you can bear it, look upon my mother. In my eyes.

There.

Here.

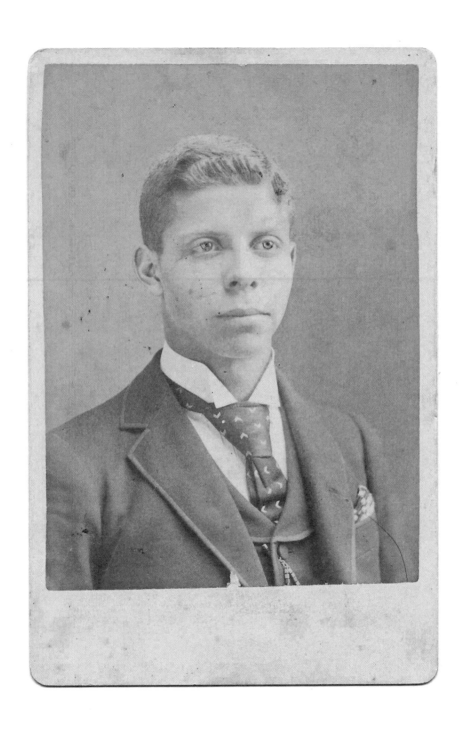

I seethe. You stare. I wish you'd disappear! *Again* you've mistaken me for one of those muddy tainted Negroes! Why, this faultless nose alone should say that I was clearly born to better. Look—it screams that I'm just as crowned as that white woman stopping to buy tulips from that cart! Or that fine man over there, watching his boy heft that bag of grain across his shoulders! Step closer to me and see—I have not a thing to prove. I am a cultured man, and every curious eye that turns my way clings to privilege and chisel. Yes, I admit that sometimes, beneath the ruthless rays of noonday sun at its highest, a whisper of that wretched skin just might appear. It shadows, reddens, browns, chaps, begins to bloom a fault you seem to have mistaken for fate. But these clear eyes, their silken milk, this slick unbothered hair, and—by the way, did you hear all the wondrous words I've said that couldn't, in any way, be theirs? *Tainted. Faultless. Cultured. Unbothered.* My God, *privilege*? Standing before you as one of you, I state, clearly, so there will be no misunderstanding—*I am not your Negro.* Nor anyone else's. Atlanta so unnerves me with its step-around, its fat pointing finger, always looking for liars. I'm only what I was born to be—an upright man demanding all the rights I'm due. As for the coloreds, I have befriended a few, out of pity. How it must thrill them, to be spoken to by a man like me—

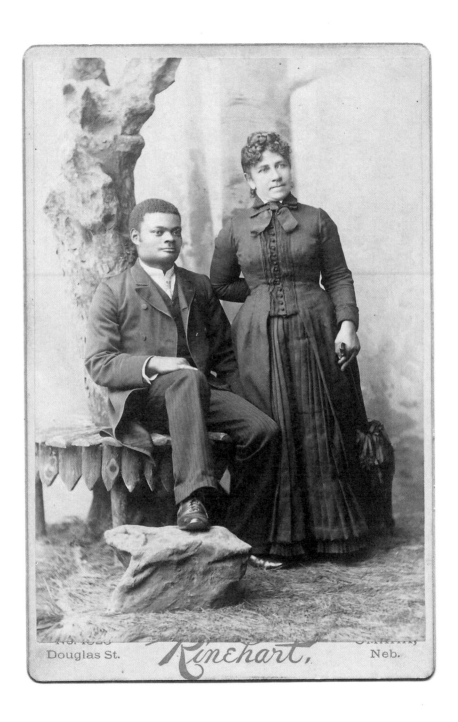

No. 1625
Douglas St. Rinehart. Omaha,
 Neb.

11

Jim ignores the fraying
of his lapel, the grime
crusting the hem of his
work shirt, the red squeal
of the scrapes that mar
his arms and the backs
of both his hands. From
soil to sky, he's building
a home. He works until
he weeps, claims to love
me with more of his self
than he knew he owned.
I give him this square
body, nights of my voice
in his hair. I give growl
to a task. I slop the pigs,
pound nails flat, and live,
muscled and spent, next
to my man under a sun.

I cannot give him a son.
So we devote all our
days to the craving
and thirsting of our land,
its always open mouth,
its cries beneath the snow.
The two of us held on
to an edge of Nebraska
that tried its hardest to
shake us loose. But now
look at us in these clothes—
fine thread, stitched right,
and the only things
we have ever borrowed.

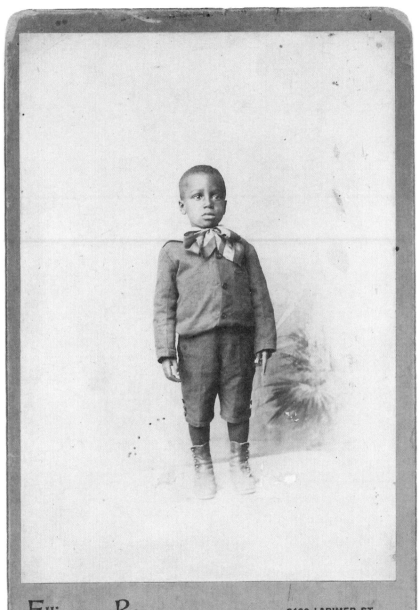

12

Daddy left me with one souvenir—a mutt,
a knotty mess of snaggled tooth and yap.
That dog just hated me. I'd sneak up near
his drooling trap,

and right away he'd let me know the plan—
your head inside my mouth. He'd snarl and snap,
wouldn't ever stop or plop his mangy rear
down for a nap.

I couldn't get him to beg, lie down or sit,
or answer to his ugly name. *I'll bite
you if you breathe,* he breathed, and I believed
he sho' was right.

I spent my boy days terrified. I smelled
his musty rot 'round every corner right
up 'til the day he died. I never knew
that kind of fright,

and wondered what my daddy's lesson was—
why he left me a dog that lived to sink
his fangs into my leg. *Get used to him,*
Pa said. I think

he must have meant to toughen me, to show
me just how crazy close I'd always be
to hate I couldn't turn to love. The man
I am can see

the truth in that. But now I wonder if
I dreamed the mad dog real. He's gone from sight.
He left the fear, nothing else. And was he

black

or white?

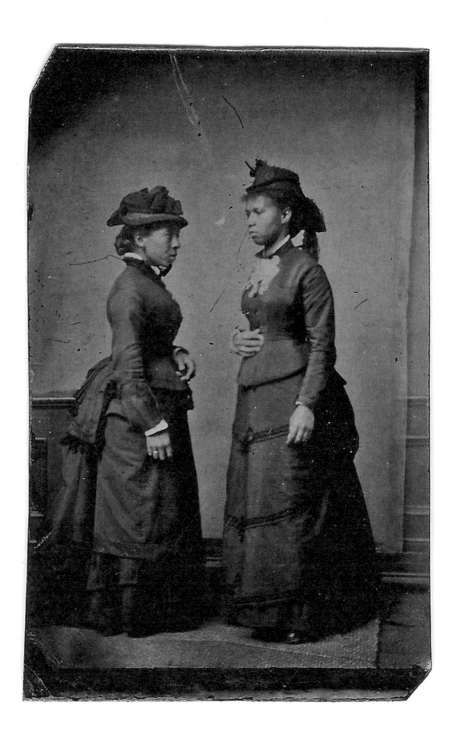

13

We ache for fiction etched in black and white. Our eyes
never touch. These tragic grays and bustles, mourners'

hats plopped high upon our tamed but tangled crowns, strain
to disguise what yearning does with us. The white man

sputters, angered by our stiff distance: *Drape your right
arm there, across her shoulder! Move! Move in closer!*

*You're cousins, sisters, servants in the same house? Why
stand so far apart? Like strangers? Here!* Paralyzed,

mute, I try to crush the memories of your mouth's
sly moonlit trip down a trail to the center of

this body—just another complication I
will have to die to forget. And I cannot move

my hand, so terrified am I of unleashing
the howl it must conceal when your swept glance—*That's it,*

now look at her!—thunders in my neck. I want this
done. I want to own this flat fixed sentence of tin

so that everyone can take as gospel this chilled
restraint, and we can just keep on whisper-living

our lush life—which we will, whenever the night, our
blacker sister, indulges us and cloaks the moon.

Wires

139 Broad Street,
Lynn, Mass.

14

Their faces stuttered, stripped

of light.

Her grimace The

 strike

A curse rises up

 grinds

The man wrangles with wrath

 rears back

 monsters the Grace

in her name

 They clench

my shoulders

Beg us not to kill

 the girl I am too much father

in my silence

 I taught Grace to command

her damage

 to throw back her head

and laugh

at the width

 of the wound

Krumhar Bros. 225 SUPERIOR ST. CLEVELAND, O.

15

Our past has done such awkward work. The rules make food of wounding:

In a large bowl, sift together the flour, baking powder, salt, and sugar.

Puppeteer, he bangs my head to tilt it. I look like a dog who hears a sound.

Make a well in the center and pour in the milk, eggs, and melted butter.

This stool staggers.
When it collapses, I will flail and nigger-beam whole perfect kitchens.

Mix until smooth.

His fingers minstrel my shoulders. Beneath this frothy skirt, hair needles the gingham. A cock is shamed and sweating.

Heat a lightly oiled griddle or frying pan over medium-high heat.

A cock is shamed and sweating.

Pour or scoop the batter onto the griddle, using approximately ¼ cup for each pancake.

Anything for guzzle. Anything with an improbable side of swine. Anything at all for the American mouth.

Brown on both sides

They argued. Was there enough kneel in my face?

and serve hot.

He smacks me again, adjusts the volume on my shit-eating grin.

His hand begins to mean that he is hungry.

You can move, he says, *when the box of us is perfect.*

16

Conjuring a woman is maddening. Such feeble guarantees.
I dare first what is needed—the store-bought blouse, its
treasured frill and stiff curl of cotton. The bogus bar of gold
greening at my throat. I dare sugar in practiced poses while
three overlooked hairs waggle on my chin and light struggles
through these flawed hillsides of hair—hair oiled heavy
and patted toward a quite uncertain she. What a weak
and reckless way to step forward—sitting on my hands
to quiet their roped veins and ungirled work, hiding blunt
mannish nails, bitten just this morning to a troubled blood.
I hiss-suck every air while the button on my skirt strains
and my thick toes, accustomed to field, spread slow purple
and bawl in these beautiful borrowed shoes. I sit taller,
name myself crepe myrtle, camellia, burst of all hue.

Tell me that I have earned at least this much woman. Tell me
that this day is worth all the nights I wished the muscle
of myself away. It will take my mother less than a second to know
her only child, her boisterous boy, steady pounding at his
shadow to make it new. Here I am, Mama, vexing your savior,
barely alive beneath face powder and wild prayer. Here I am,
both your daughter and your son, stinking of violet water.

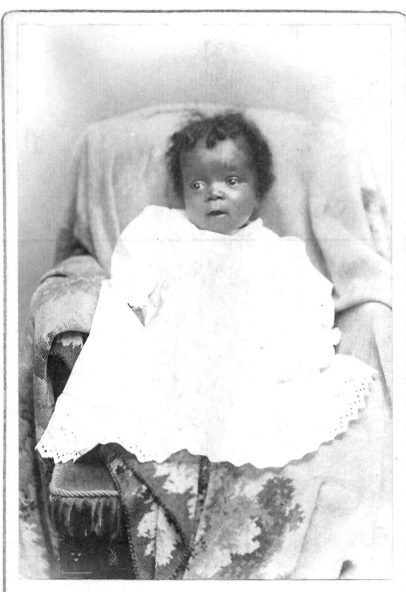

W. C. Bell Cor. Market & High Sts.

West Chester, Pa.

17

Jesus, azure-eyed, regrets His fools,
stupefies the swarm with fitful miracle.
Some children are meant to undo an old dust,
some to startle loveless homes.

Pushed out into bleak flourish, I was why
my glum mama scrubbed everything, why daddy
scarred his thumbs with smoke and cursed into
coffee swirled with lightning. I was that desperate
day in church, a one-handed heft for an old reverend,
a wail and flailing under tepid water. I was named

Rose, after the thorn. I was unceasing mouth
and night noise. I was overblessed, too soon fed
pieces of Christ, a timid amen at the end of what
absolutely no one was praying. So it made the most
sense for me to die, to unripple what bit of air
I'd stolen, to toddle backward into holy gesture.

Pomaded and overly frocked, swollen in gospel
lockstep, the congregation wept feral over me.
I was every head of singed hair, I was every
chilling organ run, I whipped the assembled to flame,
I was barely half a soul beneath my little dress,
I was my mama's unlatched eyes as she thought
Soon be time to go on home. She had crusty pans
to scrub, nuggets of pig on low boil, wiry hairs to pluck
from the skin of supper. She'd have to stop her man,
the father of a dead rose, from trying and trying
to climb into a shattered picture frame to hold his daughter.

Suddenly all the dust undone.

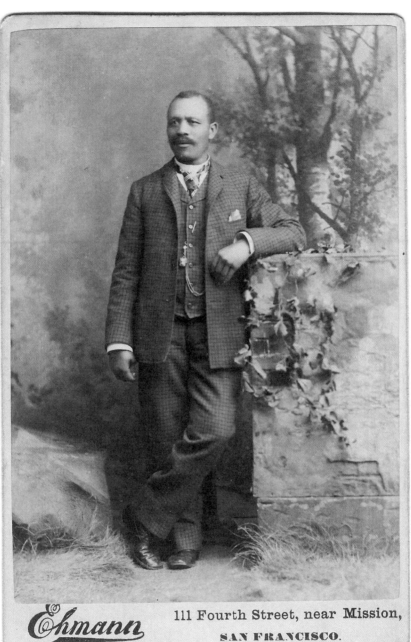

18

Still fixed on Northern stars—how it must pain
to stay so damned enchanted, pining for a loosing
without name, just knowing that it's bound to be

rapturous, blinding, and exalted by a scrambling
baritone that always comes from nowhere. Oh,
and the arms and arms. This in-and-out of love

with the gap in horizons woos us, but only when
we're very weary—*wait, wait, so soon,*
it's coming so very soon, soon, just wait—then

free falls on our heads like some gold afterthought.
No matter fresh meat is scarce and coins are slow
to the hand—some ungainly door sighs open and

we're beholdin' again—crammed into splintery pews,
speaking meekly to soil, twisted in impulsive jubilee.
Caramel women make mirrors of window shards,

char their crowns, drape not-quite-dead animals
over the bones in their shoulders. We're free to
hoard, to bemoan our own dark, to treasure chunks

of lard in sink-side jars. We sway saintly over a square
of what we can't own. Strange how those many manifest
arrows, scoured so prettily by moon, always seem to

point to where we aren't. Strange how nothing stops us.
All we need is a winding lane, some sad riverway, and we're
off again, fresh havoc on a trail meant to leave us all behind.

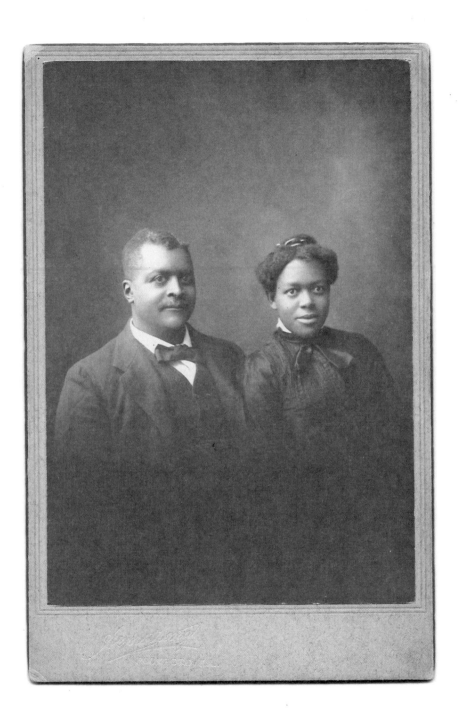

One day, our scions—
sons from sons, our rumored free
and restive children
born of mothers who were born
of mothers whose mothers were

born only to know
the drench of a devilish mouth
will recognize the thirst to be overboard,
to pry babies from the sapped teat,
bless them with the briny slap of salvage.

To yet another crusted rail
they'll haul their squiggling young.
But they will hold on,

knowing the ship will founder.
It founders, always.

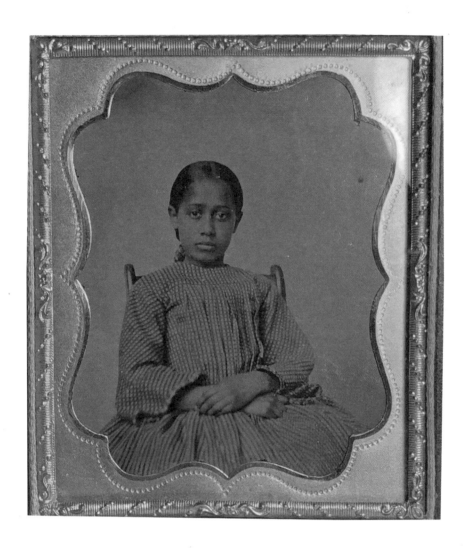

I could be your confounding daughter, wide-eyed in the ways
that puff your chest and make you keen to father me—
or a sibling, curling into sleep, deciding not to see.
Your awkward finger hovers, heats, then falls to stray.

Let your imagination reckon on my name. Obsess
on facts a pining stranger seeks. You're not exactly sure
if I'm a child—another gangly immature
rapscallion blooming new inside a Sunday dress—

or if this coy and luminescent glare suggests
the hallelujah of a *yes*. I can endure
your stomach-churning, ill-considered hope—this lure
is snagged in history. Allow me to confess

the women coiled inside my chest—unhitched from industry,
midnight and seething, ageless wailers. Their tenacious clutch
is all my body is. So when you wonder if your touch
will spark a smolder, we say *yes*. Come here. Come close to me.

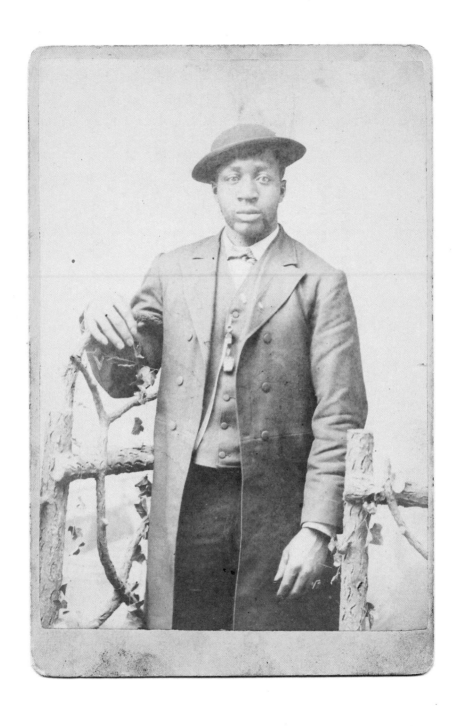

21

I swear, a wound was all I wished for. The dying
I didn't need. But he just kept swinging, slugging
toward a spew so vile I heard one of their women
cry out *Mercy!* Even in swelter, splashed nearly
blind, I'd have tipped my hat if I had had one. I was
kinda proud, kinda satisfied to have stunned her.

I reckoned on bruising, maybe some bubbled gray
bursting that would weep, thud 'til numb, and shut in its
lazy time. But the mob circled, looked straight on with
its crazed out-of-control eye, and right clear I could
hear my ol' daddy—*Blood is a monster they know.*
I saw how hungry they were to share my going,

how they bonded in doe-eyed glee awaiting one
of those long, delicious, Negro tremors. My wound
bloated, a vein behind my eye popped and flooded,
and I retched, gushing a bright dinner that mingled
with exclamation and the heartless alley moon.
Wait, wait. Wait and see if he begs, if he dies. If

he begs to die. And even I couldn't blame them.
Who wouldn't want to witness that random waggle
of God's finger just once? Who wouldn't want to look
into a man's eyes at the second his life packs
its tattered bags and deserts him, as the baying
pain dims its drum? Grant them that one outlandish grace.

After I'm gone, they'll trod home to stir their muddy
stews, slurp spirits, fuck, and babble about the boy
who seeped so slow into the street. But then, the itch.
Under streams of scalding water, they'll scrub their hands
so hard welts rise, but the prickling won't cut them loose.
They'll crow their glum upheaval. Then they'll beg to die.

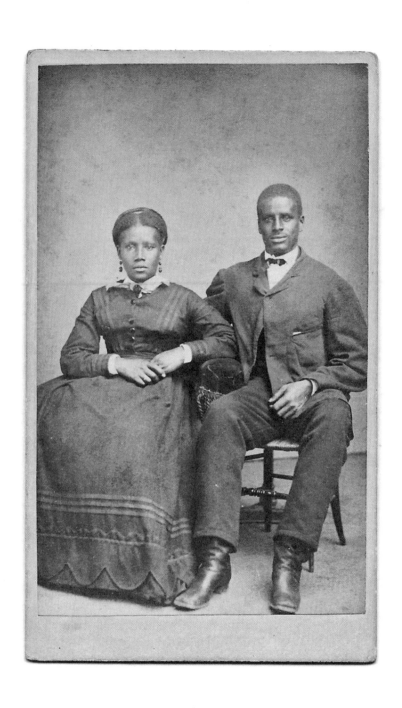

I won't forget. He was considered prey. On land that grew
so thick and golden he just knew his Lord had stomped it sweet,
my father, Harry, snapped his bonds and fled the rampant heat

of Carolina twisting through his name. Of course he knew
his rabid keeper, Mr. Jesse Moore, was sure to be
a stinging blow behind, commanding fevered curs to seek

his double-crossing vassal's fragrant blood. Anguished and weak,
my frantic father coiled inside a hollow poplar tree
for seven months of days. *Boy, just didn't know that I could do*

that kind of lonesome. Papa ached through seasons tucked away
from everywhere, no longer sure there'd ever come a day
his Lord would find him there. He cried from moon to moon and slew

the horrid snakes that thrust their heads inside the hollow, fed
himself on sprouted taters and the lazy bloom of chance.
There wasn't much the same man left of him when Providence

descended to unbend his body. Everything he said
'bout then was like he couldn't recognize the dawn for what
it was. I heard. My name is Moses Grimes, the youngest one

of Harry's eight. I'm wedded to my Susan, have a son,
and I live free in Syracuse, New York. There, on a plot
of land beside my home, a poplar creeps its steady way

toward Daddy's sky. Sometimes I walk on out to peek inside.
What fiery voice rose up, convincing him that he could hide
for all those nights inside that musty reek

and still reach day?

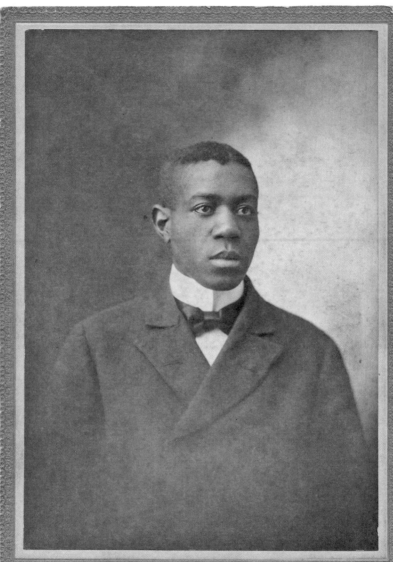

Hughes & Sandberg HS 205 N. 16TH ST. OMAHA, NEB.

Beneath my dusty chic, I'm here each day—
devotee, starving student. Right up front,
I clutch my scribbled notes, expecting, once
again, to be both unnerved and consoled,
to be upended by the wrath and weep
of her, to hear too many oft-told tales
of grisly magic troubling the arms
of trees. I cannot rest with all I do
not know. She's heard the unloosed whoops, the wry
hysterics of the men who always come,
delivering on promises of flame.
She knows the brawny branch, the broken wail.
Miss Ida B., Miss Wells, my mama church,
says I am always closer to the noose
than I will ever be to where I stand.
She strikes me dumb with numbers—I take up
my pen, unkill the names. I etch a long
and messy line of final moons. My seat's
always in front so she can watch me live.

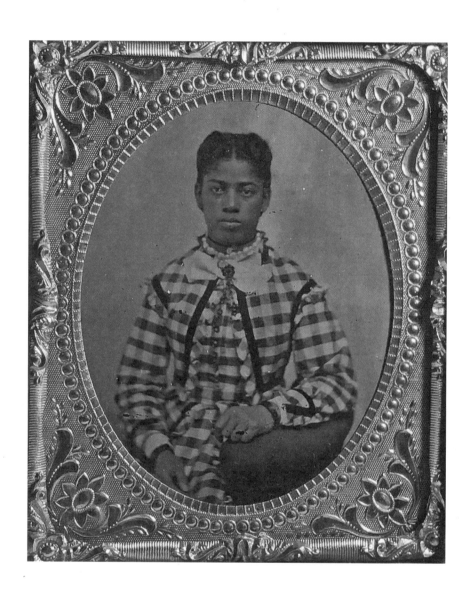

24

You're driven by your thirsting for a pawn.
You covet me. And so I pose. You see
a jeweled mute, a prized accessory,
a sunrise you can latch onto your dawn.

A word I held too close for you to hear
you never heard. And now, my sir, it's late.
The gilded me behind your gilded gate
believes her skin. I warn you—don't come near

what you assume you own. Because you fear
the weakening tendrils of your vast estate,
you cataloged your property—*Placate*
the negress, count her too—but didn't I hear

you croak this Negro's name on nights your whole
disgusting bulk of body begged me near?
I turned away, so now you prop me here
among your assets, frame my sneer in gold,

make me the crowning glory of these mere
mementos you, deluded, have arranged.
I too am a collector. And it's strange—
your spine makes such a pointless souvenir.

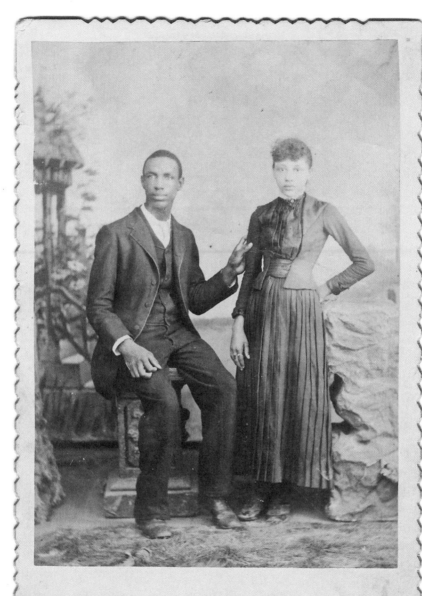

Gebhardt. *Memphis, Tenn.*

25

I

Photos of our daughter's dwindling stare are now arrayed
wistfully on shelves, in the thickening dust of tables.
We live our dwindling lives around them, sharing gloomy
plates of cool meat, weeping in and out of the window,
scraping yesterday for clues. Once every day or so,
we lift the gilded frames and then simply set them down
again—lovingly, we think, but afterward the room
looks smaller, our way of love even less possible.

Her vomit was black, gums slick with bleeding, skin greasy
and jaundiced. The Yellow Jacket swept like a whispered
torrent over Memphis and hit the Negroes hardest.
My years as a doctor couldn't fight this diagnosis:
They're filthy beasts, and everywhere they are is dirty.
There was no cure. We were taught to rely on dying.

II

It's been one long year since we stripped our dear Eva's bed
of the flowery and fevered sheets, spiced the firewood
to banish her smell, and sat across from the pudge-faced
undertaker to get her rawboned body ready
for the earth. He gaped at the sight of her in pictures.

Losing Eva snapped the slender thread that held us close.
From every shelf in the shadows, so many of her
look down, die again, tell us where our mornings have gone.

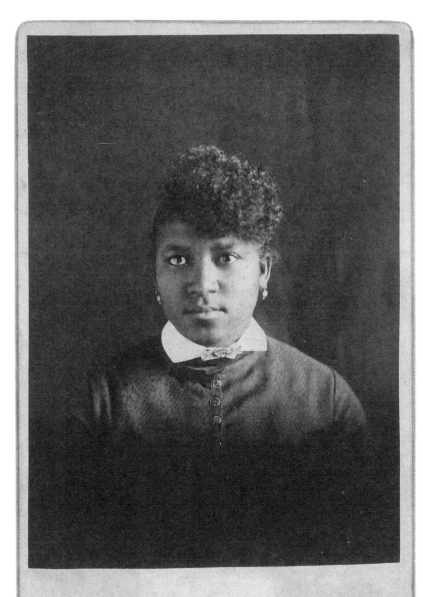

On shelves of shadowboxes, their warnings
waned to sepia, still lives

still
live

in unbearable magic

Youth stunned
and captured

a second before
the second

Please don't breathe
You must not blur

 Any flaws will go
to sepia *Stay still*

Dare them this beauty
 hush

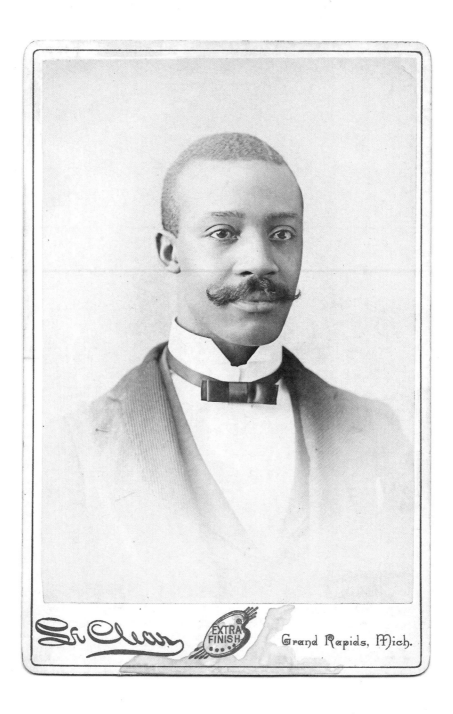

St. Clair EXTRA FINISH Grand Rapids, Mich.

27

In sepia, still hushed and numb
to color's awkward ecstasies,
I fear that I have now become
accustomed to suppressing light,
so my illicit memories
swell loudest on the starless nights
when I'm alone. It drives me mad—
the trail of tongue along the necks
of splendid men. (*What if I had
said that aloud, and someone who
had gathered all the power to wreck
my shrouded self decided to?*)

I miss the man. My only sheets
are sweet and reeking, guaranteed
to hold on to the ebbing heat
that's always all I have. He leaves,
my keening bares a bluing need,
and what is left the Lord receives—
me, kneeling, naked, sheathed in sin
I'd die to live in. Must I pray
in words I shouldn't know? Within
me is a wild I long to claim
aloud. My savior, lead the way.
Unveil the ways I say my shame.

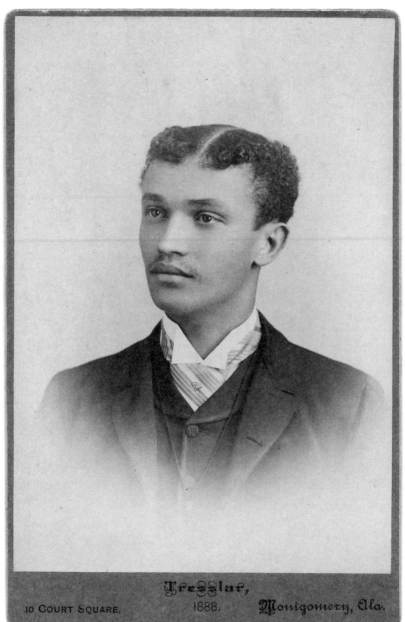

Tregglar,

10 COURT SQUARE, 1888. Montgomery, Ala.

28

There's no way I can hide
what it is that they become,
or what became of them.

Each morning, arm in arm
with our Sarah—my boy Micah stumbling
behind—I pass the crumbling
auction block,
ghosted, slick with algae.

I step up
onto the blighted slab,

lift my son
 to answer what he asks
 (*When?*)

But the sun wants its rise

so badly,

I straighten my back for him

 and I walk

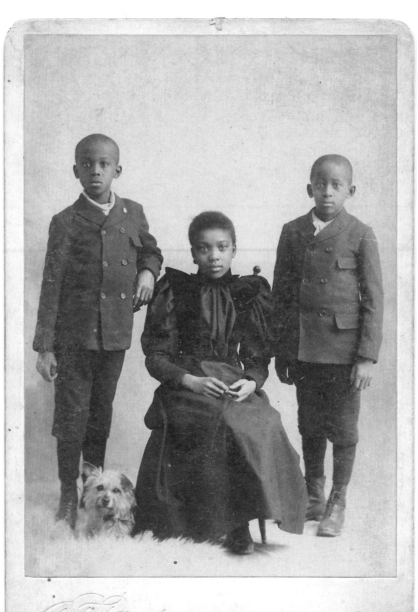

Quiet at the table! Sit upright! Straighten your backs! For us,
it was Mother and Father who made the rules, but through our own

language, the babble of the secret threesome, we conjured
dreaming apart from them. If we had ever thought they'd known

how deep our oneness went, we'd have become the three instead of one,
just Mae and James and Robert, one and one and one, each alone

and not together, no muscle in our number, no little thefts
around the house, no all three of us catching a cold—the groans,

remember, and the retching, all that stink at once? We don't
know just when we became this we, what day had threw (or thrown?)

us all together, but we know why. *I love my brothers,* so
spirited and sly, and yes, *We love our sister,* who's so grown,

who shields us when we're too much of us. Mother and Father, before
we came, you dreamt much noisy love for us. How could you have known?

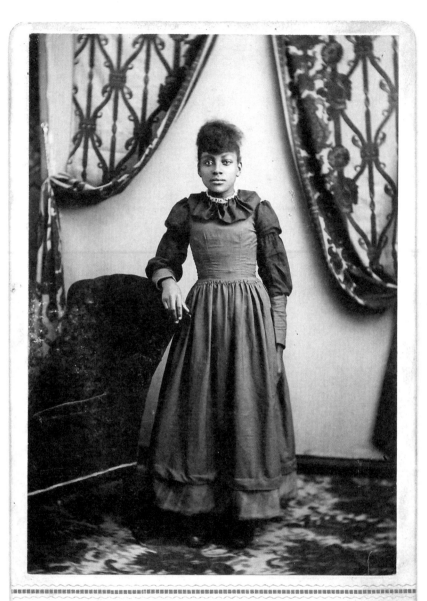

30

When they were fathoming my name

roping verb to question when they
mulled over an echo this clumsy blossom could own
could they have
known
 (imagined)
that I was
 such a blunder in the air
 such stormwater
such their child
 in another child's frock

 could they
have (imagined) why such a useless blue

trifle of me
 would scramble so eerily for air and not know the difference
 between whiskey
 and welcome

I just—

wish someone had told me
 that age would
ache

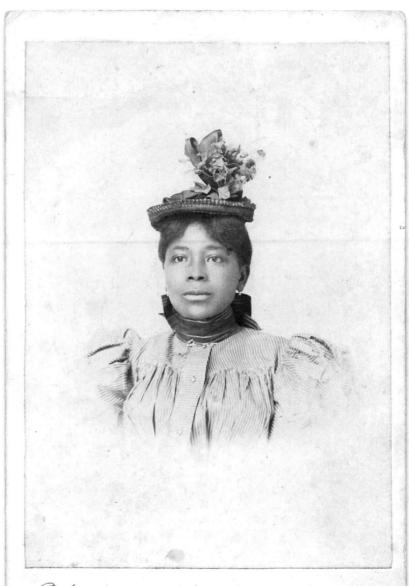

Walter Noel, Wytheville,
VIRGINIA.

31

If you want to know how much escaping never ends,
I just might be able to help you understand it.
Early one March, a drizzly Monday morning it was,
almost a hundred men—nothing but yellow-bellies
and weasels, under masks, scared white with their own sinning—

rushed the jailhouse here in Wytheville. (Just so you know what
kind of place this is, coloreds supposed to be joyous
just to strut these nasty cow paths call themselves sidewalks.)
Those hundred—you can bet I knew all of 'em—arced their
hateful selves over that sad milksop of a sheriff,

snatched keys, and stole my baby brother William from his
cell (*his* cell, like he had any choice in owning it).
Everybody—'cept for the colored folks—say our Will
killed that wild, no-'count Joe Heirt, who sure deserved his end
quick, by somebody's hand if not my brother's. Oh, and

in Wytheville, *everybody say* the same as *he did*.
They hung that poor chile from a beam in the mill, and while
he swung they took their shotguns and fired and fired into
that body that already wasn't William's body,
making sure it was dead like disappearing his head

wasn't enough. Next day, just like magic, nobody
knew who did anything. 'Cause they were everybody.
I've been trying not to slap the smug off their faces
ever since then. Smoke driftin' off their teeth when they smile.
They touch my shoulder, speak their slow shit, try on grieving.

William was a good boy, Sarah. He's sure gon' be missed.
But I'm my brother's only sister. I know my place
on the sidewalk. I keep fury away from my face,
away from my shuddering fists, and keep it knotted
inside, just beneath my everyday. There no one will
smell it. There it won't hurt anyone it doesn't know.

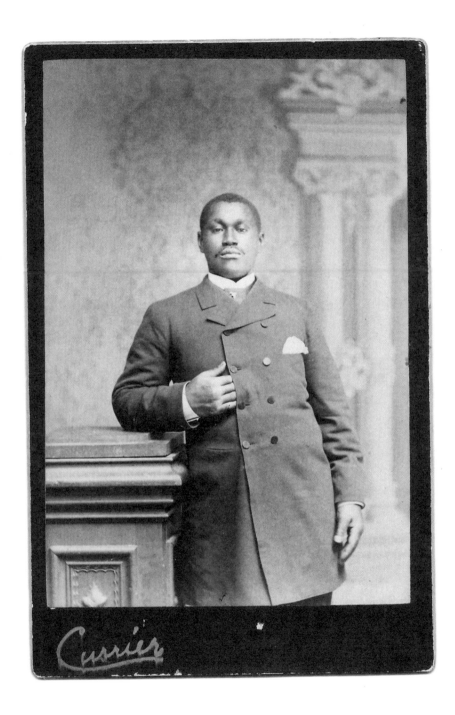

32

We had grown canny to the chase, the hunt, the metronome
pursuit. They craved their due, their docile bloodied trinkets,
and they were mesmerized by maps of blood that they could
coax at will to our skin. They wanted us to believe in a peculiar
romance, their warped idea of love—*You need our need of you.*
They even blessed us with their names. Lord, look upon their
purity, their spewing of white grace even as we lie prone beneath
their stomp. But, while you're blessing them, let them know how
unwise it is to say *I am what savior is to you* and expect us to
believe. I am Josiah, my own savior. I spent years persuading
myself to this height, and years stepping high to the rhythm
of faith. I see their wretched love for what it is—a jumble of
oily words, practiced and delivered from wobbling pulpits—
and I have grieved the many who listened and remade themselves
in the image of those with the ruin of our hearts at heart. It's time
the blackest among us realize that love never involved blared
ownership of the body, that you are what savior is to you.

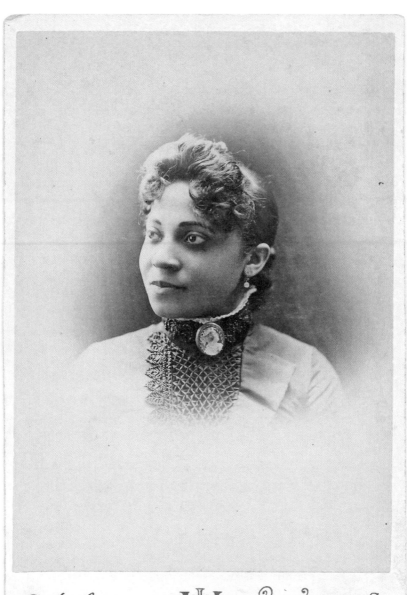

Wilson 389 STATE ST. CHICAGO.

The dispatching of our children,
dying splayed on beds
too short for their bodies,
elders drifting to misted
motherlands, their wrists
tangled with purple veins
and marks left by the screech
of the wrong needles. White
cannot be the color of what
saves us. The next colored
person who looks up from
pain will see me. There is
a colored hospital now,
close, on a street with
a name they know. It is
here to stop the meandering
kill, the callous goodbye.

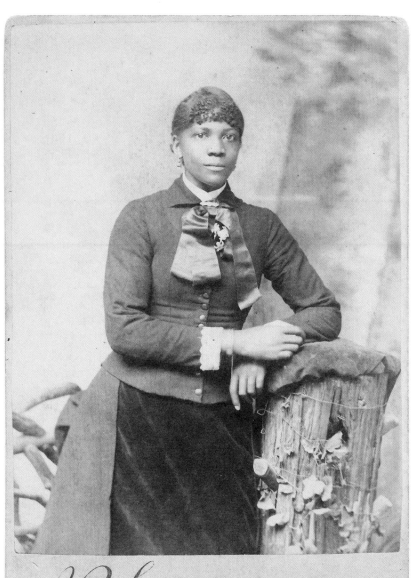

34

I

Down streets with names I thought I knew, the swift eclipse
of everything I was began so simply—old nags nosing
that creaking carriage toward the cemetery. It was August,
a damned blister of a day, but I wanted to follow
the dragged-out dirge on foot. I was a barren mother
sheathed in reams and reams of black, leaden cloth.
I wanted to stink like my dead son so that folks
lining the way—gaping, murmuring, pointing boldly
at my lusty collapse but not knowing a note of Caleb's
name—could sniff the acrid air and cough me into
disappearing. I mourned lurid, like someone without
language. Shoved all the way blue, I mourned with
my dragging stride, with snort and snot, with my spurned
curls smashed under a complicated hat. I wept wide
like an opened cage. I cried whole lying Bibles,
screeched the backsides of hymns. I heard someone
say *Lawd, that boy dead, she might as well be dead too.*
At his graveside, church folk held me back as I fought
to hurl myself into the damp mouth of his next mother.

Ten years on, the graves in Lebanon were robbed
of their dead. Negro bodies were piled high and carted
off in wagonloads so that bleached white amphitheaters
of bleached white men in bleached white smocks could
pull them apart in the name of stolen science. Caleb,

I assume your bones everywhere. I assume your heart,
carved thin and needled, refused them. I assume that
anything they couldn't kill again was shoved aside,
reckoned useless, thrown back in the direction
of mothers.

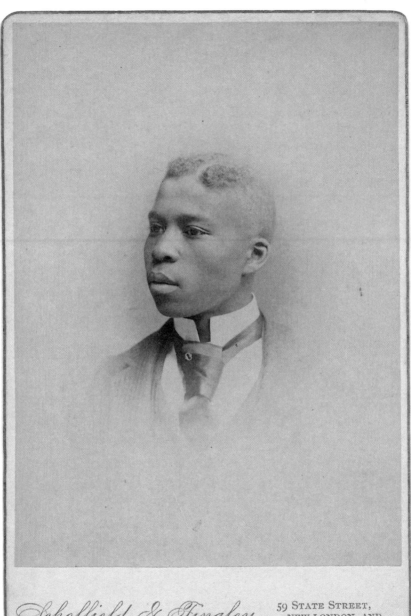

He told us, his son and daughter,
about the sun like a nail behind
his eye, how the patient fingers
of ocean beckoned and beckoned
to his body. And about the time
he knew he would have died for
that water's rough salt, that slap
in his mouth—while he lay with
a man's ass numbing his neck,
a woman not staring and not
blinking, another man wheezing
such slow verses of melancholy.
He scraped his teeth across the gray
bones of fish so many days dead.
Son, they whipped me for not
eating my morning food. But they
gave me no food in the mornings.
The dead were dragged up, their
skin dribbling into the deck, then
heaved and slung without blessing
over the cracked rail of the ship.
And the ocean slowly loved their
bodies down. How would it have
felt to have that biting flow rinse
the rum and gunpowder out of
the open wounds on his back?
We never saw our father's back,
not bare, although my sister said
she saw voices move beneath his
work shirt. When he told his stories,
the words were silent, so we had
to sit close. Cecile and I gathered
at his ruined feet, his ankles pocked

as if irons still snapped around
them at night. We listened to our
father, loving so hard the whole
relic and stumble of him, and each
word pulled us closer and groaned
beneath us like the deck of an old ship.

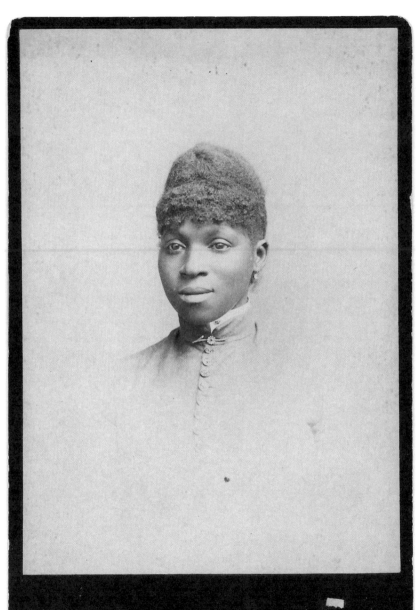

36

Our floor groaned beneath us like the burdened deck
of the ship that sailed my father toward a wrong name.
Cecile, are you sure you want to hear these stories?
he always asked first. I was the baby girl, too fragile,
he thought, for yesterday's clamor. But hearing his
stammer was the only way to really know my father—
not the man who raised up me and Jonah, not the man
who could laugh with all the inside of his mouth, not
my mother's guide and dazzled follower, but the father
whose eyes always burned outside of where we were.
We knew that he had learned to sleep upright, dying
to be loosed. That he had so wanted to kill, to lodge
a quick blade deep into the gasping of his captors.
He took his time telling Jonah and me any of this,
his old voice sliced through with much more old.

Whenever we went into town, he would point again
and again at the near-empty wharf behind the Custom
House where the *Amistad* had been moored for a year
after being hauled here to New London. In his mind,
every ship was the same, all one name, all one
purpose, all one monster. The undone skin spanning
his back whined as he straightened to ask
if we could hear
anything.
Anyone.
Anything at all?

I would take one hand.
Jonah would take the other.
We'd lead the trembling man home.

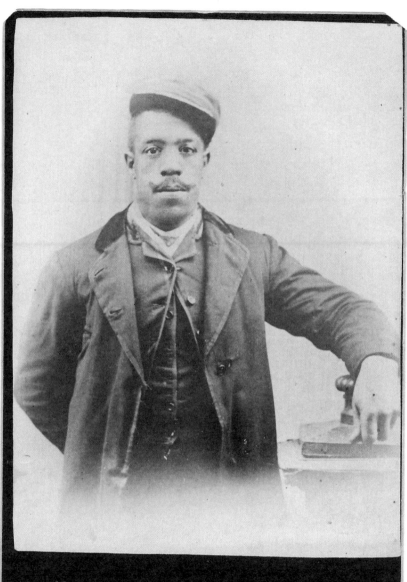

37

Seems that I was born to follow some fateful script—
the hero dies and dies, and keeps on dying,
but meanwhile, he's living life the best he can.
Not many Negroes made the money that the railroads paid,
so we moved like kings through colored streets.
But it was different way back when.

Virginia Central needed sweat, bought thirty men
for $80,000, Negroes all of them. One of them
my father. That just meant he'd be another kind
of slave—see, colored work don't come with choices.
But as soon as I was born, even before I stood and knew
my legs, I wanted toil that looked like his. So, side by side,
the man and I laid track through headstrong land,
hauled spikes and ties, pummeled our lungs with black powder.

I worked my way to brakeman, leaping 'tween
the shifting roofs of hurtling freight cars. I flailed
on the films of ice, hammered by gust and storm.
Sometimes the train staggered on a crooked track,
and remnants of unloved life unreeled inside my head.
From way up there, any day the hurtling failed to kill me,
I saw boys die. I saw men fall.

When the years of muscling shut my father down,
I held his last collapsing in my arms. He died, I stayed.
Louisa found the wreck in me and loved it hard,
so when I finally had the means to marry her, I did.
I had a job that pledged my body to the track. It built
us a home. And how I saw it, scrambling in the clutch
of speed was as close as a man could get to God.

That God and I, we rode and talked. Come of think of it,
He didn't say much. The ride never seemed to take long.

38

I prayed, but it was never right.
 I couldn't give the words the strength
to wrap around him, words
 that would keep me
from knowing his blood
 before he bled.

The morning my man, on the top
of a speeding train car,

lost that clench
on the
 sky

I heard him say it, plain—
 Louisa

I woke from a dream of
 the gruff song in his hands

I woke to

 weep and ball lightning, my hair
a vibing wire

God, I am a selfish woman—
 tell me that he prayed for me

 and not to You
 when he caught his breath

 and knew

there was no way

not to
 fall

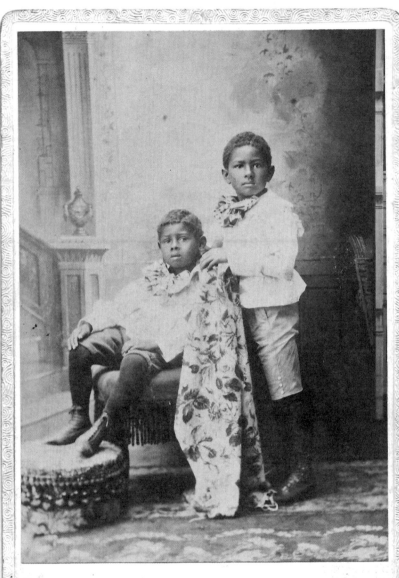

Millerton, N. Y. **Grant, Artist.**

Art Studio.

39

We hold and hold and hold our breath, and wait
to slip into the frame our mother chose—
one meant to fence in rumble, calm our red
relentless rush, our rampant thrash and roar,

our take on manners. We're forever mates,
so much our father's boys. We whirl in throes
of brother weather, oh-so-surely bred
to stomp our landscape flat, to burst through doors

that close to keep us out, just heading straight
for everywhere at vicious speeds. We pose,
we vow to sit here, tame and still, instead
of ripping off these itchy shirts—just for

our mother, who's in such an awful state.
We look so much like Father—no one knows,
except for her and us, that he is dead.
Eli and Amos, just one minute more!

And then, although she doesn't say his name,
we welcome Father back into the frame.

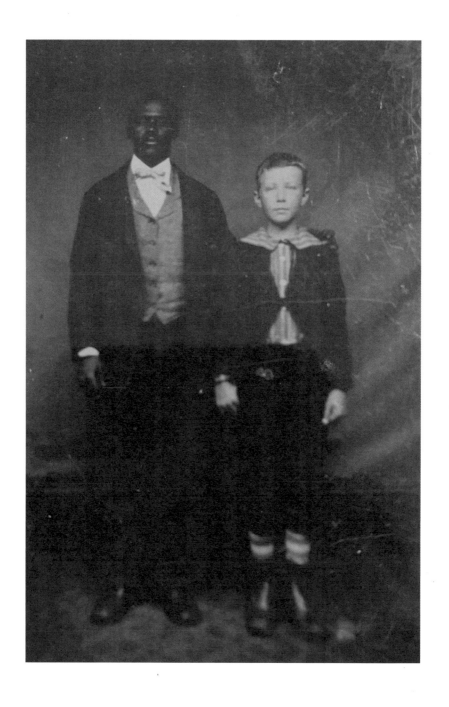

40

Inside the clutch of flash. *Don't blink.* We freeze.
The light unearths our buried selves, the grim
fidelity we hide. Already, we
are tired of posing in these tightening clothes—
this collar working deep into my neck,
that snap screaming its hold across his chest.
Stand still! the white men bark. *Don't move. Don't breathe.*

He'll whisper *Jim?* as soon as this is done.
Luke likes to know I'm never far away
although he feels me standing next to him.
We'll mumble 'bout the time, the crazy work
of staying still, the moan in both our backs.

Here's what I know: he's older now, and so
much taller. He'll be growl and grimace soon,
just like his pa. We'll leave this place and walk
straight into what the summer does—his bare
and bitten skin will chap, and underneath
that sun, I'll probably turn the kind of blue
that turns me blacker than I am. And when
he notices, my Luke will rub and poke
that mojo, search for runaway color
on his fingers. Then we'll mosey on down
to Alum Creek, hook some squirming supper.
He'll grin at me and say, *Jim? You are still
the bestest nigger who I know.* But now
me and the boy, us two together, burned
to tin—that means that it's the two of us
for good, don't it? No one can take the me
I am away from him? My life is his?

Now, get on home, they finally say. I sigh
and reach down for his hand. He doesn't take
it. Not a once in life has Luke not took
that hand. He lifts his head—and dammit, it's
his daddy lookin' back—his daddy, who's
been tryin' to teach the boy that when it comes
to me, ol' Jim, *need* ain't the same as *own.*

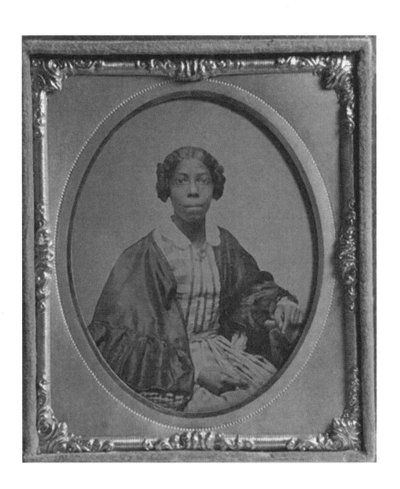

41

They were captivated by a story
we both knew they needed, a story
that would both grant them root
and grieve them. Cecile and Jonah
clutched every syllable of the grisly
storybook their father had lived.
Of course, they always wondered
how it was possible for me to lay
down love for such a maddening
man, a man whose whole face could
wrench toward history without warning.
They had seen me stifle his screams
and cuff away the specters that exploded
his sleep. What was he to them—a man,
a martyr, a lesson that misted so easily
into myth? Their questions troubled
the water, but he put voice to every
one. And when his son and daughter
wanted to see his back, he was silent
for a moment before turning away from
them and asking me to lift his shirt.
Gingerly, they touched their fingers
to that wretched landscape, then those
fingers slowly began to move, tracing
the twisting routes they had to travel
to lead their father home.

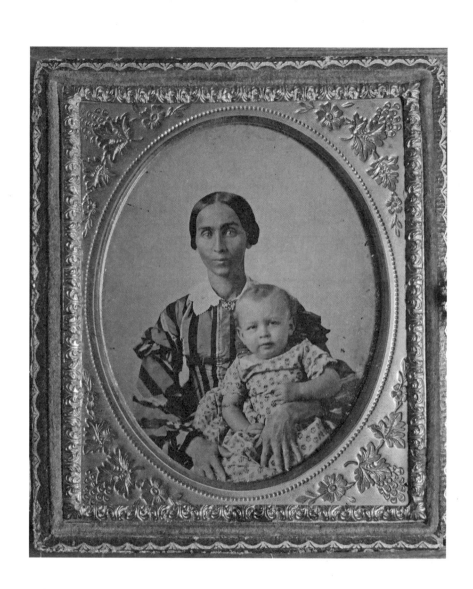

42

Their Story

She takes forever learning to read
the signs: she has no life outside of it.
She breathes so the child
may breathe. She should know
what a blessing there is in service.
She should know that she was
born to be drained,
the child to be filled.

My Story

I am nauseated by the thing—its mewing,
its meek need, the begging that so quickly
veers to screech and claw. I have learned
the perfect way to mimic cool love, cooing
damnation while I cringe at its weight,
its sour squirming heat on my legs.
I sit on my slapping hand when a new tooth
drives through the skin of my breast.
Its first word—spat toward me—was the same
name its gasping daddy calls out in the dark.

How sweet of mister and missus to want
this golden token of mammy and sweetums,
cow and suckle. Cow honed the blade this
morning. Cow needs to carve her given name
into a new throat. But for now, Cow is content
to doom us all with this one last stoic glimpse
of me.

UNSHUTTERED

You damn us with these stoic glimpses. You,
officially composed, gracefully caged,
you're girdled, stifled in your overdo
of buttoning and lace, so stiffly staged.
A waylaid rage, illuminated, can
become such softer fist within the held
and holding breath. Instead, the light—engaged
with cane, cravats, and corsets that retell
the body's mishap—blinds us to the hells
that seethe within your stare. You disappear,
dim gingerly to fray on a lapel,
and leave us with this dogged souvenir—
the ache for fictions etched in black and white,
our faces stripped by lies of shuttered light.

The past has done its awkward work. It rules
our now with such a feeble guarantee
while Jesus, azure-eyed, regrets His fools
still fixed on Northern stars. It hurts to be
your scions, sons from sons, your rumored free
and distant daughters, floundering in ways
that wound. And all you asked for was that we
never forget you were considered prey
before this dusty chic, or how each day
was conjured by your frenzied thirst for dawn.
Instead, your desperate stares are now arrayed
on shelves of shadowboxes, their warnings gone
to sepia and still. We hush your drum,
and hide behind whatever we've become.

When you were straightening your backs for us,
and fathoming our names, could you have known
how much escaping never ends? We must
grow canny to the chase, the metronome
dispatching of our children, dying prone
on streets with names you'd know. The swift eclipse
of sons and daughters, days that moan
beneath us like the burdened decks of ships—
as if we're following some hateful script
you prayed we'd never write. Back when you posed
and held and held your breath, waiting to slip
inside the clutch of flash—*Don't blink*—you froze,
captured a story that you knew we'd need,
a story we're just learning how to read.